VIN RUDE

Photographed by David Thorpe.
Written by Pierre Le Poste. Designed by Martin Reavley.

M

Styling by Barbara Drake.

Typography by Nigel Kent & Steve Shannan.

First published by Macmillan London Limited
London and Basingstoke. Associated companies in
Delhi, Dublin, Hong Kong, Johannesburg, Lagos,
Melbourne, New York, Singapore and Tokyo.

Printed by New Interlitho, Milan.

British Library Cataloguing in Publication Data
Le Poste, Pierre
 Vin rude.
 1. Alcoholic beverages - Anecdotes, facetiae,
 satire, etc
 I. Title II. Thorpe, David
 641.2'02'07 TX597
 ISBN 0-333-31500-6
 ISBN 0-333-30977-4 Pbk

"Never drink water. Fish fuck in it."
W. C. Fields.

APPELLATION CONTROLEE

Ah, the French. They're so *strict*. Those two words mean that the wine in the bottle must come from the specific area mentioned on the label, and woe betide anybody who tries to pull a fast one.

Punishments range from fines and imprisonment to several years of enforced grape-treading, so beware the wine-shipper with prematurely purple feet.

While Appellation Controlee does guarantee that the wine has been properly made and honestly described on the label, it doesn't necessarily mean that the wine will always be good.

You can be unlucky, and get a perfectly genuine bottle with almost undrinkable contents.

We like to think that the severity of the Appellation Controlee system was devised by the Marquis de Sade, but he obviously had his mind on other things, and the system didn't come into formal effect until about 1935.

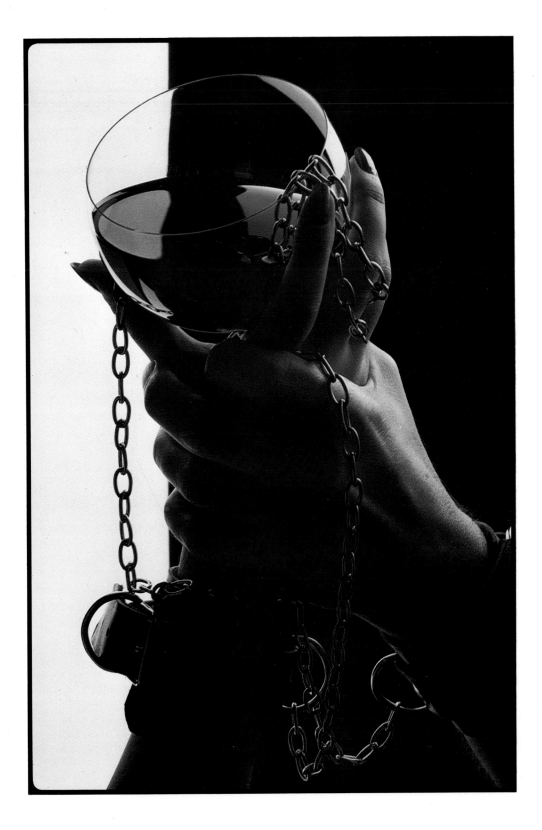

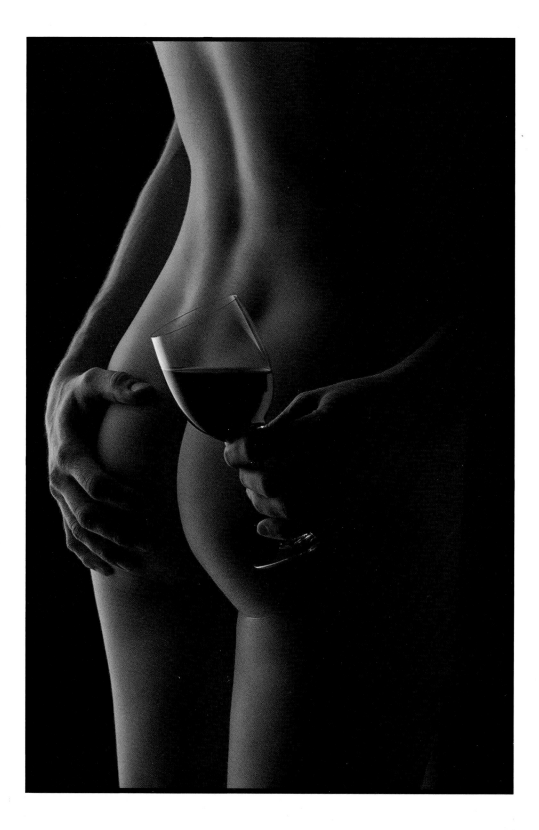

BODY

Not to be confused with alcoholic strength, body is more a mixture of sensations than a precise measurement. One of our more lyrical and lecherous friends describes it as the oral equivalent of cupping a perfectly formed pair of bare buttocks in your two hands.

The only trouble with perfectly formed buttocks, as he readily admits, is that you can't drink them.

Connoisseurs often go overboard when describing a full-bodied wine — chewy, weighty, profound, orotund, etc. — but we much prefer bare buttocks.

CORKSCREWS

Judging by the variety of complicated appliances on the market, you would think that taking the cork out of a bottle is a desperately difficult business.

In fact, it should be a most enjoyable moment of foreplay, to be conducted as far as possible by you rather than by some terrifying mechanical device.

The lead or plastic capsule which covers the cork and upper neck of the bottle should be neatly circumcised, the corkscrew inserted and pressed home with a firm screwing motion, and the cork withdrawn in one full and satisfying pull, complete with a gasp of delight from the bottle as the cork comes out.

For this agreeable little ritual, we have found the simple 'Waiter's Friend' type of corkscrew by far the most satisfying. There's a small knife at one end for the capsule, a good hollow screw in the middle, and a lever at the other end to assist at the crucial moment.

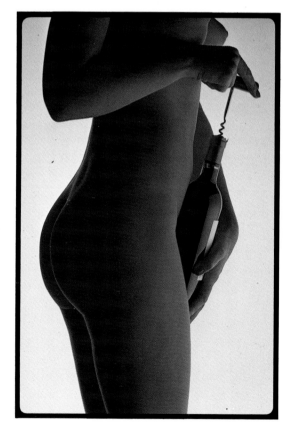

DOM PERIGNON

Widely believed to be the monk who invented champagne during his long career as the cellar-master of the Abbey of Hautvilliers. On first tasting his invention, he is reputed to have said "I am drinking stars," and promptly got into the habit.

He died, blind but happy, after more than forty years in charge of the cellars.

Today, Dom Perignon is a superior and expensive brand of champagne produced by Moet & Chandon, shipped in bottles with slender necks and low shoulders, and often consumed by girls with slender shoulders and low necklines.

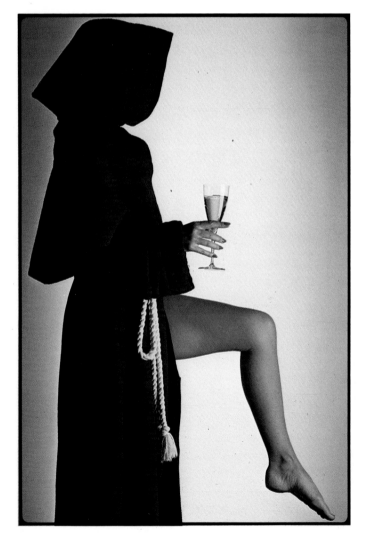

ELEVENSES

After a hard night between the sheets, nothing is quite as restorative as a glass or two in the middle of the morning.

If you have missed breakfast due to more pressing matters, we strongly recommend a nourishing mug of Black Velvet—half Guinness and half champagne.

The froth from the Guinness clings to the lips, and the bubbles from the champagne work their magic further down.

Very popular in Victorian times, as were large families.

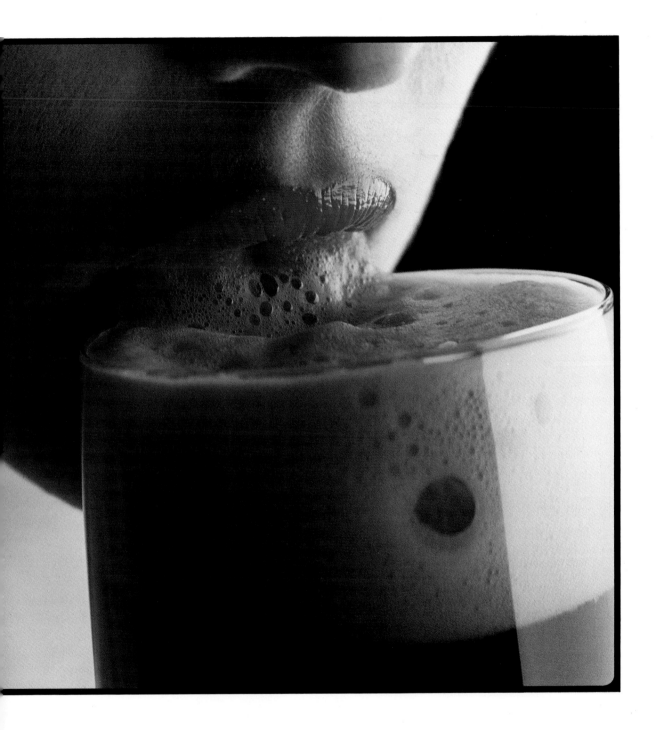

FRENCH SHAPES

There are eight basic bottle shapes for French wine, the differences being in length of neck, size and slope of shoulder, and contours of bottom. (Some have a dimpled bottom and some don't.)

Here's a quick guide. To help you remember them, try running your hands over the shapes in the dark, starting at the neck and working your way down.

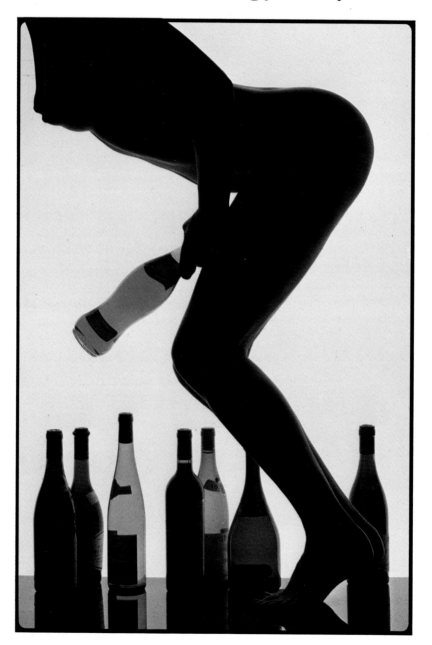

CHAMPAGNE

The easiest one of all, because of its distinctive neck. Some experts pour champagne by inserting the thumb in the dimple and clasping the bottom firmly with the fingers. Not to be attempted unless you're sure of your grip.

BORDEAUX

The high, broader shoulders are there to catch the sediment as you pour. With the exception of the pouring technique described above, we are told that it's always better to "seize a woman by the waist, but a bottle by the neck". Preferably both at the same time.

BURGUNDY

Most really fine Burgundies come from a deliciously named stretch of vineyards called the "Golden Slope". If that doesn't get your juices going, nothing will.

BEAUJOLAIS

Another easy one, because of the pronounced and sensuous lip around the mouth. Beaujolais is often described as "fruity and gay". Make of that what you will.

LOIRE

The wines of the Loire—Muscadet, Sancerre, etc.—are best taken while young and fresh. Marvellous with rude seafood such as oysters.

ALSACE

Slim green bottles with aromatic and full-flavoured contents. Wonderful wine for a picnic, particularly if you have some good foie gras in your hamper.

CHATEAUNEUF-DU-PAPE

The Chateau Neuf used to be the summer home of the Popes of Avignon in the 14th century, and in those days you never saw a thirsty Pope. The wines are quite heavy, as indeed were many of the Popes.

ROSÉ DE PROVENCE

The Mae West of wine bottles, with a narrow waist and voluptuous swellings above and below. A favourite lunchtime wine on Riviera beaches.

GRAPE

The grape was probably the first fruit ever cultivated by man. Noah is said to have planted a vineyard when he disembarked from the ark, and subsequently enjoyed one of history's first recorded binges. He passed out, stark naked, after sampling his wine. Unfortunately, history doesn't relate why he was stark naked in the first place, but he sounds like a man after our own heart.

HONEYMOON WINE

Mediaeval newly-weds used to slip out of the reception early and take a couple of jugs of mead upstairs with them.

This concoction, a fermentation of honey and water, was thought to endow the husband with mighty sexual urges –"sufficient to rend the codpiece asunder", as a sharp-eyed wedding guest once wrote.

Since then, both mead and codpieces have fallen from favour, but tales of wines that bring a rush of blood to the loins still abound. We have a friend who swears by a Spanish red wine from Navarre called Castillo de Tiebas. It is described by the shippers as full-bodied, fruity and mature, and comes, as you might expect, in a long thin bottle.

ICE

Ice in a glass of Scotch is fine; it merely replaces the water lost in distillation.

Ice in a glass of wine is awful. By the time the wine is cold enough, half the flavour has been diluted away by the melting ice cube.

What you need is an ice bucket. It doesn't need to be fancy – anything big enough to hold a couple of dozen ice cubes and some water will do. (Don't cram the bucket with ice cubes. The wine will chill faster and more evenly in icy water.)

As most ice buckets aren't as tall as most bottles, put the bottle in head first for a few minutes before opening, so that your first glass is nicely chilled.

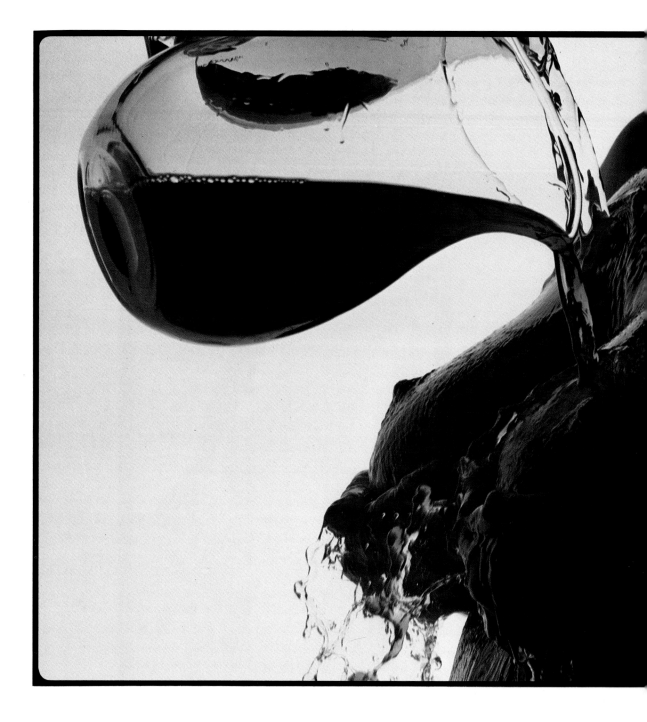

JUG WINE

The Californian equivalent of vin ordinaire, jug wine has many virtues. It's good, plentiful and, if you happen to live in California, cheap. But perhaps its most endearing characteristic is that it is sold in sensible quantities —usually half a gallon at a time.

And what could be nicer than a big jug of wine on the table? (There are no prizes for those of you who answer two big jugs.)

KIR

This is the perfect way of turning a glass of undistinguished white wine into an excellent aperitif. Just add a few drops of Creme de Cassis (an alcoholic blackcurrant syrup) to the wine until it turns a very pale pink. Don't sacrifice good white wine, and don't overdo the Cassis, or you'll end up with something that tastes like Ribena.

The drink takes its name from Canon Kir, a Mayor of Dijon, who consumed the mixture in such impressive amounts that the name was changed from blanc cassis to Kir in his honour.

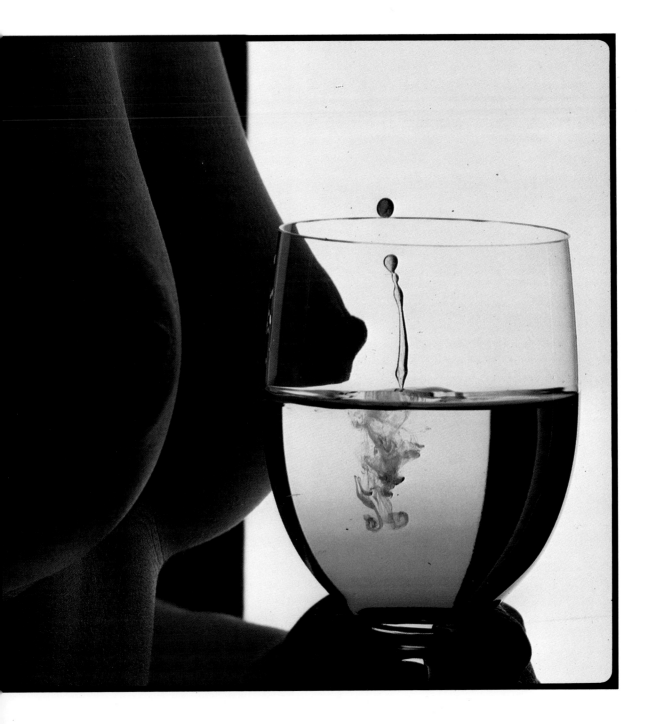

LEGS

Wine has a nose. Wine has a body. And, to complete its anatomy, it also has legs. (This is a sign of a good–quality wine; plain vin ordinaire is usually legless.) The study of a wine's legs is absorbing, thirsty work, best done with a large glass only one-third full.

Swirl the wine round in the glass. Take a mouthful. Hold the glass up to the light. You'll see that the wine forms tears on the inside surface of the glass which slip slowly down leaving legs in their wake. The size, spacing and shape of the legs depend on the viscosity, glycerine content and temperature of the wine.

If at first you don't get long and shapely legs, try again. With luck, it sometimes takes several bottles before the leg of your dreams comes sliding down your glass.

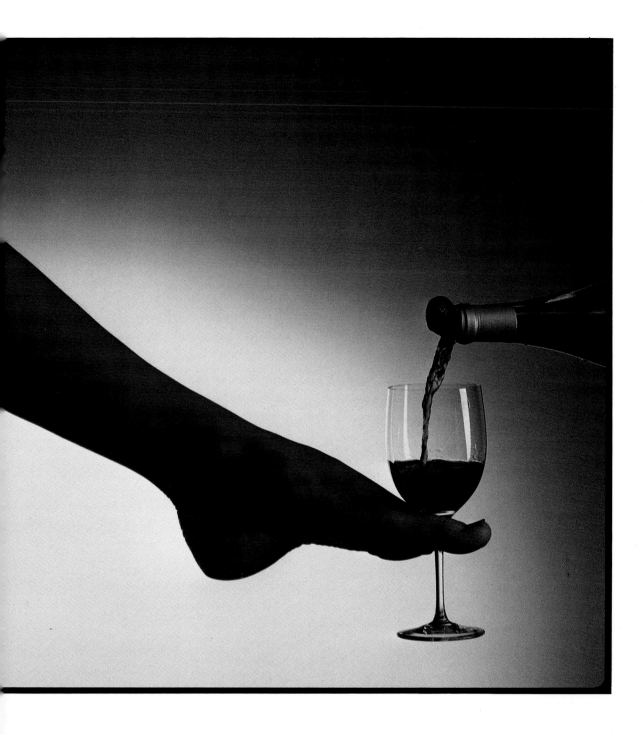

MOUTH-FILLING

We have always preferred a good mouthful to a miserly sip, but we are told by more discriminating drinkers that mouth-filling should only be used to describe certain good wines. Beaujolais, for instance, where fruitiness is the main characteristic, is a wine that "persuades the drinker to fill his mouth". We have never needed much persuasion, either with Beaujolais or anything else, but you may be different. If so, a bottle of Beaujolais, slightly chilled, will provide all the encouragement you need.

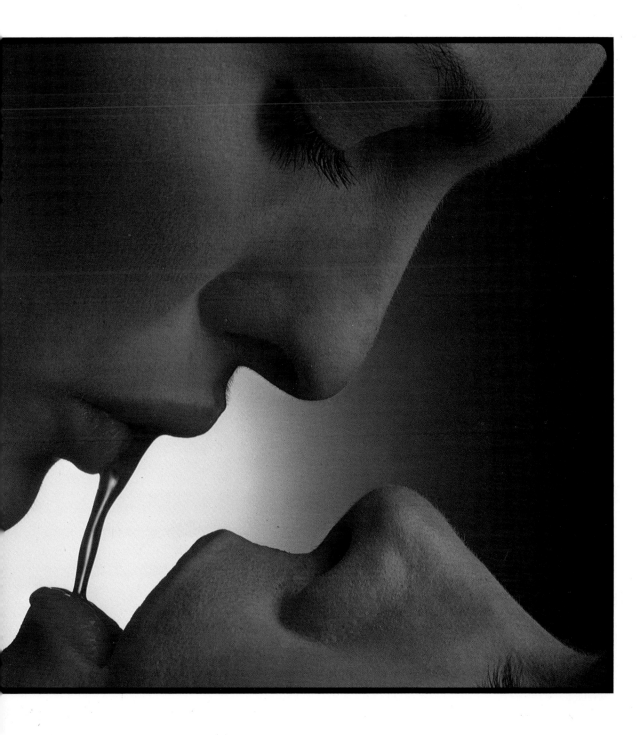

N^U

Literally means naked, but don't rush over to France expecting to find a chain of topless wine bars. The prix nu is the price of wine on its own, without casks or bottles. France being France, however, it's always possible that a little well-timed disrobing in front of the wine merchant will result in a substantial discount for a nubile customer.

OVER THE TOP

Some wines need to be kept for several years. Some should be drunk within a few weeks or months of being made. To all of them, however, comes a sad moment when they have passed their peak, middle age sets in, and they start to decline. In other words, they're over the top.

As a very general rule, pink and white wines should be drunk before their third birthday. Good red wines need a little longer. And really fine wines are often not ready for twenty, thirty or forty years.

There are so many exceptions that you'd do well to ask the advice of a good wine merchant before uncorking a bottle you're not completely sure of. Disappointing though it is to find a wine that's over the top, it's even worse to waste one that's under the top.

Incidentally, bottles *must* be stored lying down, so that the wine can keep the cork moist. Dried-out corks shrink, in comes the air, and off goes the wine.

PRESSING

A grape with its skin intact is just a grape. A grape with its skin broken will become wine. Once the yeast cells that develop on the skin find their way inside, they turn the natural sugar into alcohol.

To help the process along, man has devised many ways of breaking the skins of grapes, from the good old-fashioned foot method to hand-operated squeezers to enormous mechanical arrangements. Anything will do providing it allows those yeast cells to work their magic on the grape sugar.

Ain't nature wonderful?

QUANTITIES

Quick! What's the difference between a split and a methuselah? It's not, as someone crudely observed, the difference between a very young girl and a very old man, but a difference in bottle sizes. Turn the page for the complete range.

Split. A quarter-bottle. Normally used for champagne, or that frozen claret they serve on aeroplanes.

Half-bottle. A useful size when you're having a quiet drink on your own, or when you want two good wines with a meal without breaking the bank.

Bottle. Usually about three-quarters of a litre, although less expensive wines often come in litre bottles. Thank heavens they do. We've noticed an alarming tendency for normal-sized bottles to get smaller as we get older and more thirsty.

Magnum. Twice the size of a normal bottle. Some really great wines are often laid down in magnums, as they tend to age and develop more slowly in larger bottles.

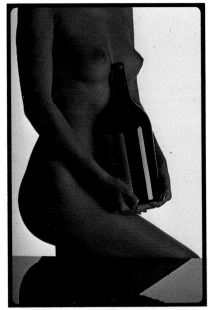

Marie-Jeanne. An unusual three-bottle size, which some people call a tregnum.
Chateau Vignelaure, a very good wine from Provence, comes in Marie-Jeannes.

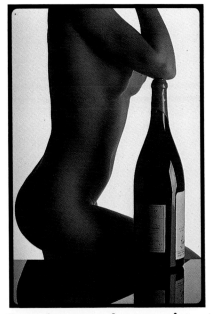

Jeroboam. Approximately the same as six bottles of claret, or four of champagne.

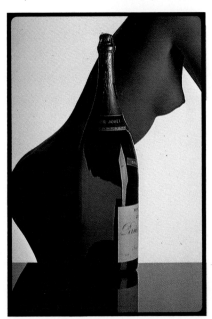

Methuselah.
Eight glorious bottles.

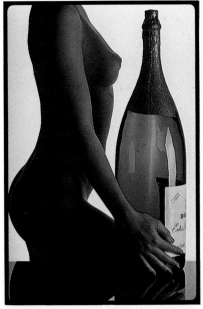

Salmanazar. The handy twelve-size, guaranteed to break the ice at parties.

ROSÉ

We used to know a young lady who had all the delightful attributes of a bottle of rosé wine; she was pink, frivolous, and went with almost anything.

Because of its amiable nature, rosé is often the first wine that beginners drink in any quantity. Relics of its popularity appear in bistros and bed-sitting rooms in the shape of empty bottles converted into table lamps —a fate that would make a claret bottle cringe.

However, perhaps we're being unfair. Chilled rosé can be delicious when drunk out of doors on a sunny morning, and one rosé in particular—Chateau de Selle —is extremely good.

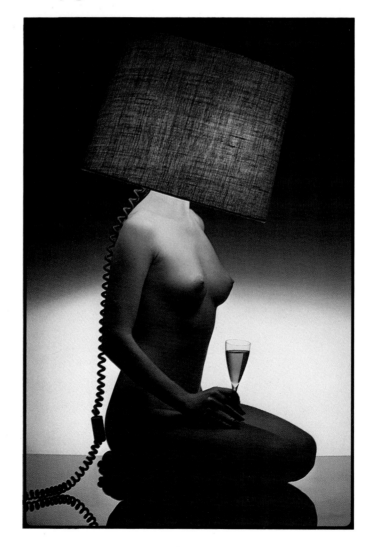

SAINT-AMOUR

An irresistibly named and very good Beaujolais. The soft, fruity wine is every bit as irresistible as the name, and should be drunk in generous quantities with a suitable companion before your afternoon nap.

Saints pop up all over the place in wine history and on bottle labels, and one of them in particular, Saint Paul, has been a source of great comfort and encouragement to us over the years.

He said: "Drink no longer water, but use a little wine for thy stomach's sake." We have followed this advice religiously.

TASTING

This should be an enjoyable moment or two of anticipation before the main event; the kiss before coitus. Instead, it is all too often either a faintly embarrassing ritual for people who are honest enough to admit that they're amateurs, or the excuse for an even more embarrassing pantomime conducted by self-styled connoisseurs.

You must have seen them. They're the people who like to keep the waiter in suspense while they're mauling the first mouthful of the house red. At last, with a flick of the eyebrow, they condescend to approve of what's in the glass, and everyone can breathe again.

This is not to say you should just slosh the wine out before trying it; tasting is important, and, as we've said, it should be enjoyable.

The most vital item of equipment in tasting is your nose. One sniff will tell you if the wine is corked — the smell is obvious and pretty nasty. If the wine passes the nose test, a mouthful will let you check the temperature, and then you're off.

U.S.A. AND U.S.S.R.

In the battle of the bottle, Russia is way ahead on quantity, producing more wine than any other country except France and Italy, and about twice as much as America. One hears tales of oceans of "champanski" bubbling away in Russia's nether regions, but not much is exported.

In terms of quality, there's no comparison.

American wines are infinitely better than Russian wines, and some are among the best in the world.

UNDER, DOWN

There are some superb wines in Australia.

Unfortunately, the Australians keep the best for themselves, and even tend to discourage visitors by the way they describe some of their wines.

How do you fancy a glass of "bloody kangaroo," or "sweaty saddle"? Believe it or not, these are terms actually used to describe the taste characteristics of a South Australian Cabernet and a Hunter Valley red.

If you can hold your nose through the description, you'll find the wine is lovely.

VIN D'UNE NUIT

This must qualify as the easiest lay in the business. Vin d'une nuit is a light red wine that has been left to ferment on its skins for twenty-four hours or less. Barely has it laid down before it's time to get up. Sometimes called vin de café (which is where you often find it), although perhaps vin de motel would be more appropriate.

WHEN IN DOUBT

Normally decisive men and women are often reduced to a state of confused disarray when confronted by a seemingly endless restaurant wine list.

It happens to us all, with the exception of the true connoisseur.

Fear not. There is one very simple rule which has helped us avoid many a costly mistake: in a good restaurant, get the house wine. (That is, unless you see a particular favourite that you know well on the list.)

There are several reasons for our suggestion. The house wines are invariably the cheapest, but a good restaurant isn't going to risk its reputation by serving rubbish. So you're likely to get something reasonable and drinkable.

Any really good red wine needs a much longer breathing space than it gets in a restaurant before it is ready to drink. Also, you can never be sure that it has been stored properly. A bottle that has spent six months sweating over a radiator is going to take some time to recover, if indeed it ever does.

Finally, avoid number three on the wine list.

Restaurant owners tell us that it's the most popular choice, as it falls neatly between meanness and extravagance in price. Beware. That's where they'll put something they want to get rid of.

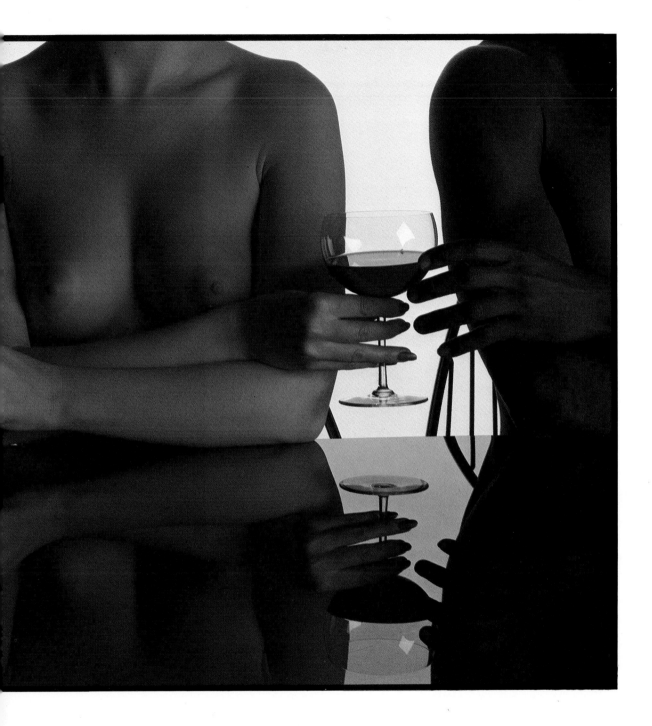

XAMPAN

Spanish sparkling wines, the best of which are made by the champagne method. These are in a different class altogether from the stuff that overflows the bars of the Costa Brava in a maddened fizzing flood.

When ordering, ask for *Bruto*. This is not a local waiter with violent tendencies, but xampan in its driest form.

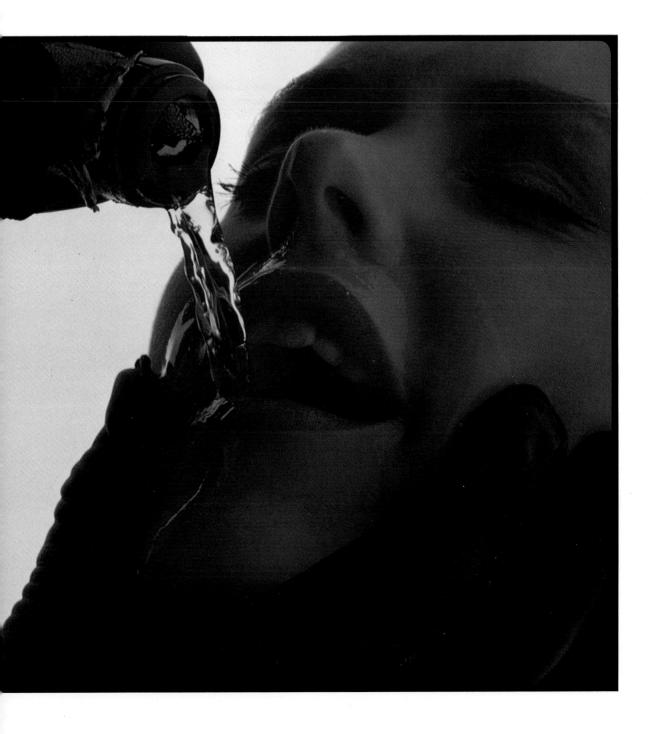

YQUEM

A Russian Grand Duke once paid 20,000 gold francs for four barrels of Chateau d'Yquem, and it has been among the world's most consistently expensive wines ever since.

It is highly scented, very sweet, and totally luscious.

Sip it after dinner instead of cognac. Some people like it with a peach, but with a wine like this you don't need anything else but a well-stuffed wallet.

ZONKED
And so to bed. Bonne nuit!